The Love of My Life

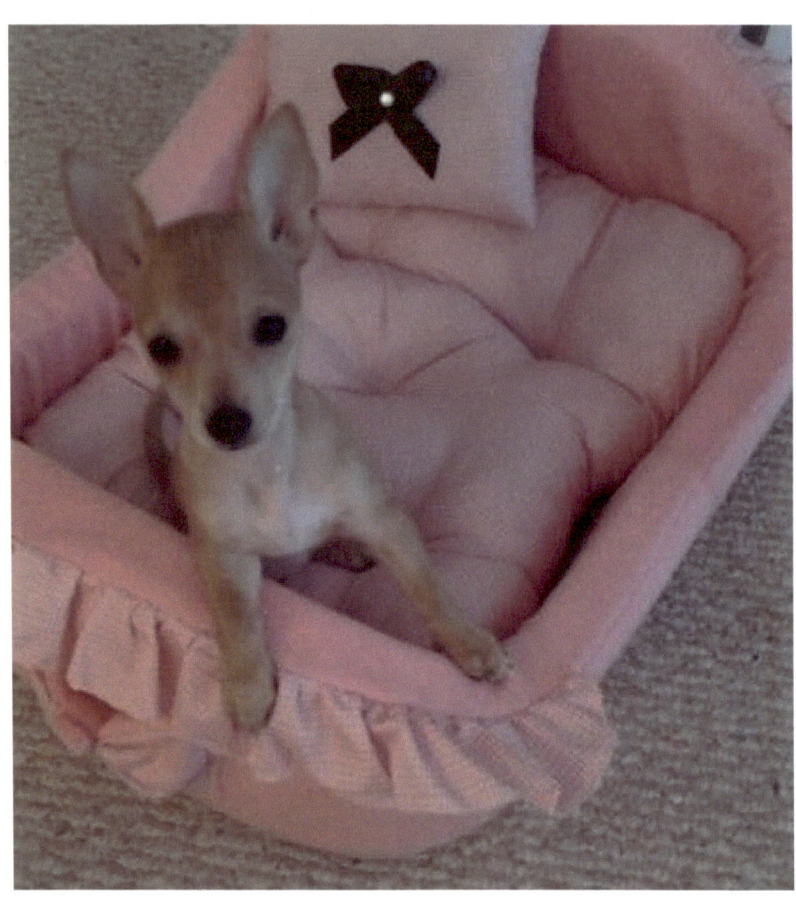

My Baby Sleeping: Peek a boo

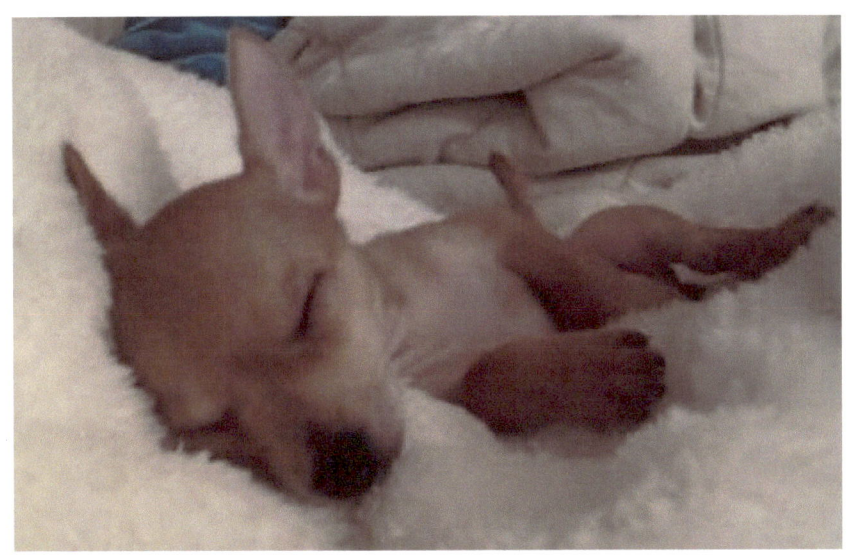

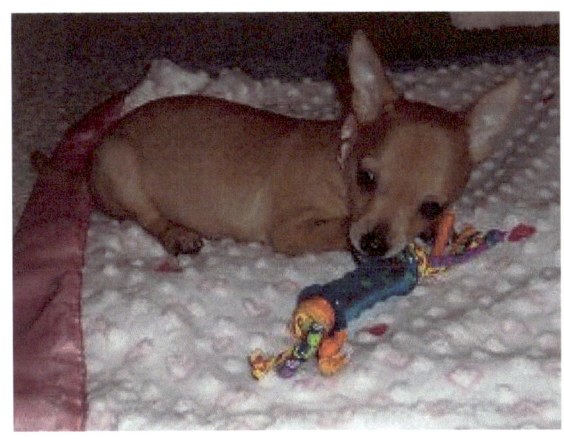

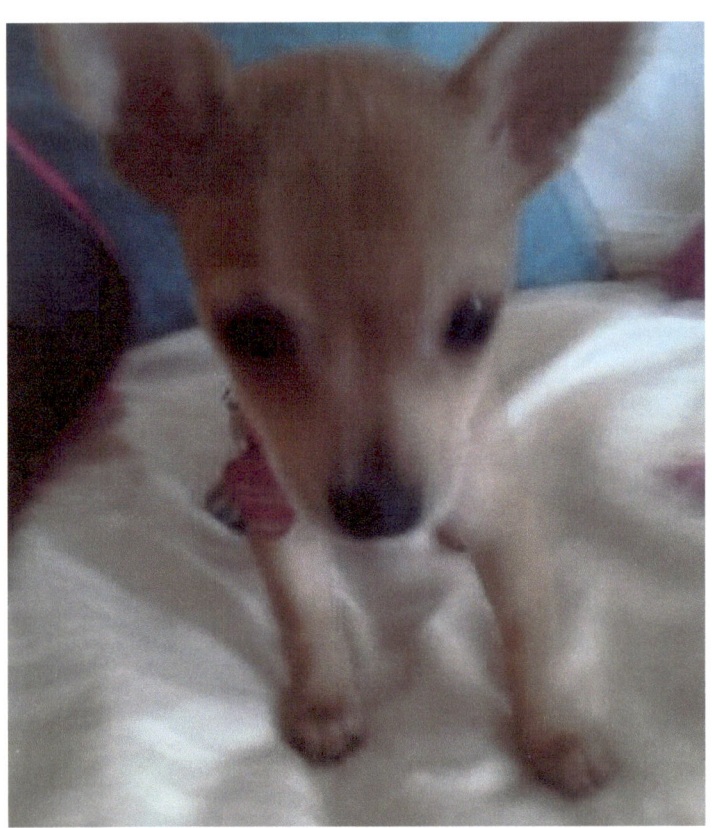

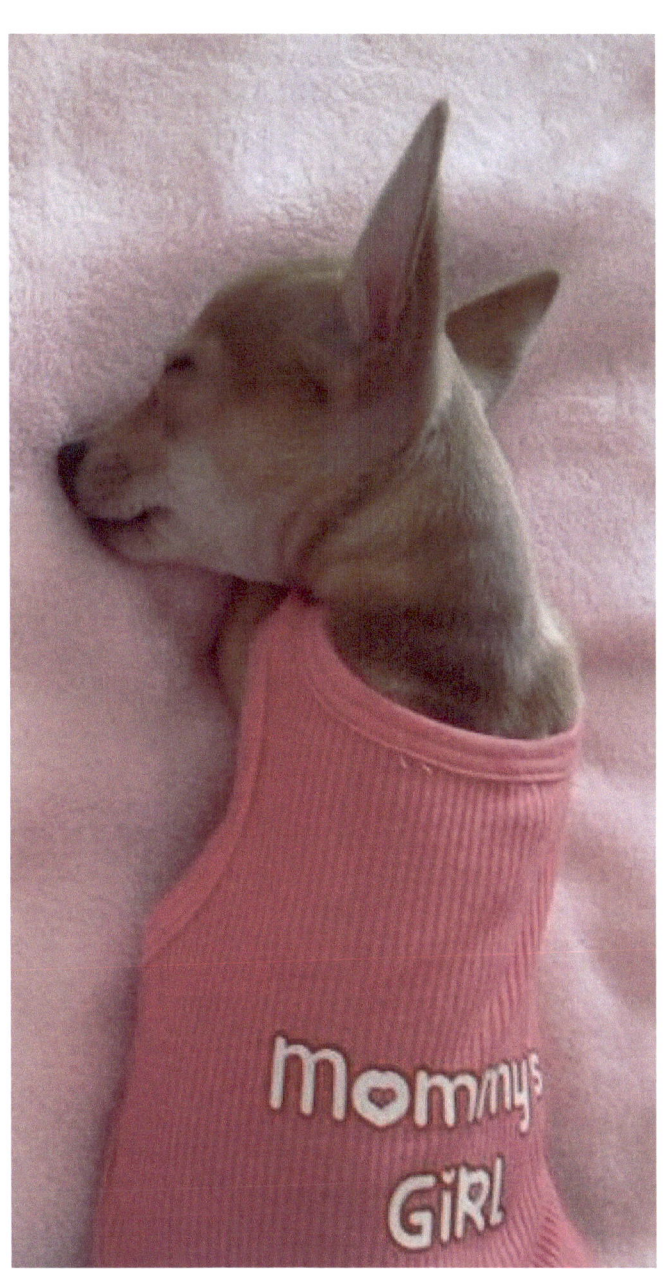

My version of: "Be in good health" from <u>art.com</u>

My painting version of: "Mother and Child" (detail from The Three Ages of Woman, c. 1905) By Gustav Klimt

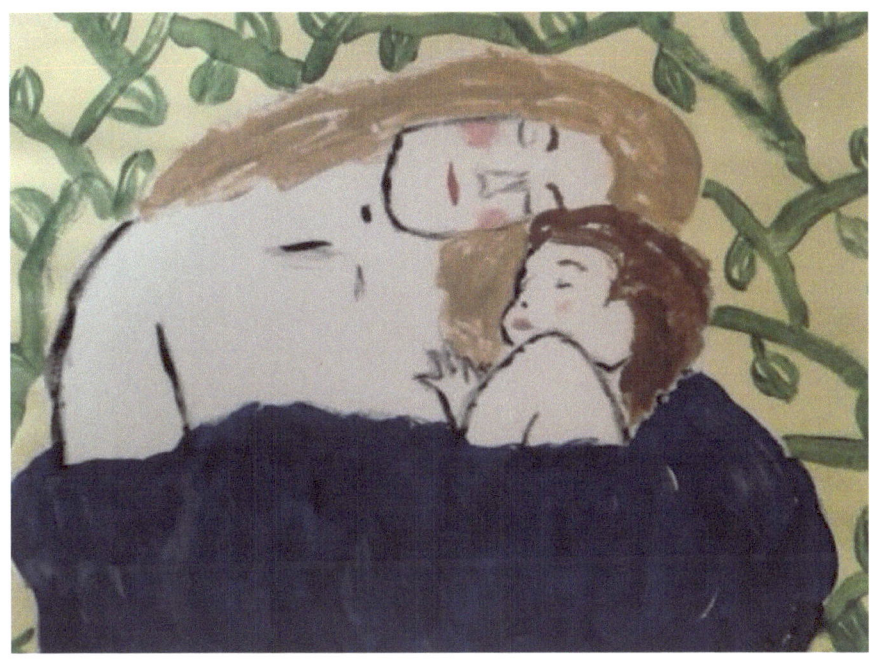

My painting version of: "White Pelican" By John James Audubon

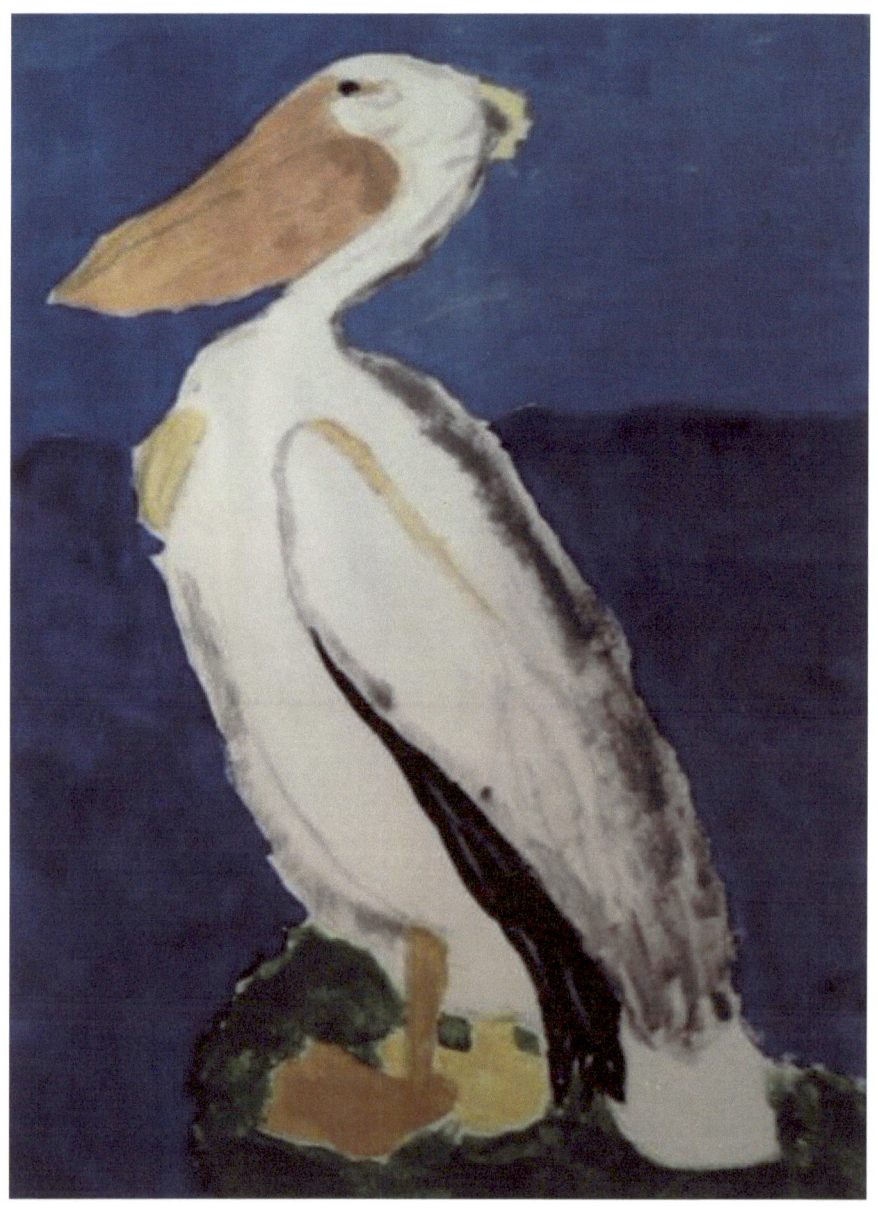

My painting version of a tree for an art class

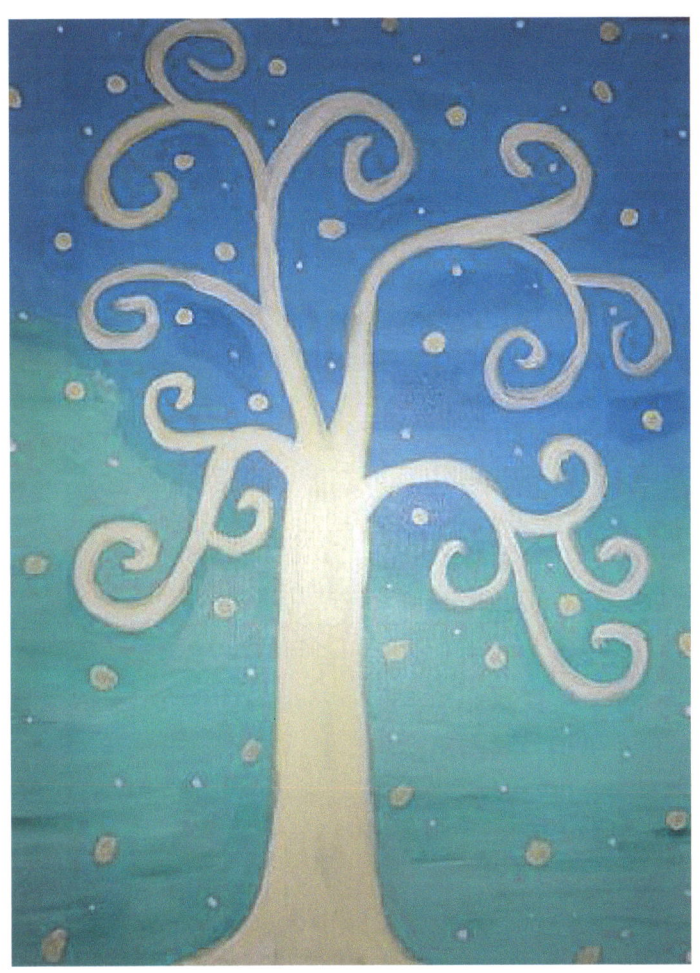

The Pope
(2/17/13)

The pope quitting
have you ever heard of such a thing
clearly
lack of a back bone
in my opinion
but his health has been deteriorating
as he has stated
whomever the next pope will be
I hope they choose
someone a little bit more vibrant and young
so that they have the ability
to change the Christian foundation
to a more versatile
and well-rounded viewpoint
that of the public
but strongly rooted
in its foundation
of right and wrong
the 10 commandments

Ill Fated "Love"
February 15, 2013

never is a guy or a girl
worth a crime
that you will possibly
commit
over them
too many news stories
of guys
and girls
going overboard
with their "love" or infatuation
for someone
who could care less
about them
the second they commit
the crime
so before you let
passion
get the best of you
remember
it isn't ever worth
losing the little that you do have
because it will all backfire
and you will have a lot more to lose
than you ever had
the notion of gaining
from the ill fitted desires of "love"

Personal Vendetta
(reflecting on Christopher Dorner, LA police officer)
2/17/13

what can I say
once he set out a vendetta
against his fellow police officers
nothing could be gained
but his life being snuffed out
when you boast about how good you are
you should beware
after all arrogance gets you
no where
but I do hope his records
are closely examined and investigated further
as he devoted much of his life
protecting us
and if he was unfairly punished
as he stated
it is a shame
that no one came to his defense

Sordid State of Affairs
(in remembrance of Reeva Steenkamp)
2/17/13

it makes me sad to know
of someone who passes
a life cut
way too short
whose life force
was so strong
how much more beneficial
is she
and how devastatingly tragic
that she can no longer
share her words
against
rape and abuse of women
which she was a firm advocate for
and to think people
like me
who don't have much of a purpose or a cause
in this world should continue on
is a sordid state of affairs

the warmth and comfort of my bed
(2/17/13)

So I was in need
of a haircut
October was my last appointment
and due to short notice
I opted for a new hair dresser
she states, "I'm single"
which should have been a big red flag
because she did nothing but blubber on and on
about God knows what
only that I was soaking wet and cold
from my hair being washed
Thankfully, she gave me a new cape
but on and on she went
again
talking about nonsensical things
and all I wished to do
was cover my ears
and scream, PEACE AND QUIET PLEASE!!
after all still getting over being sick
I felt like I was in a bubble
a head cold
which made my sinuses
out of whack
and all I wished to do
was to go back
underneath my covers
to the warmth and comfort of my bed

long overdue
(2/17/13)

taking a week off
of work is never a game plan
of mine
but after my emotions and nerves
have been running on high octane
for a few months
it was much needed
especially
when God puts a big stamp
of, "you are too sick to do anything"
and so with a runny nose
which was like a broken faucet
and cold sweats and a fever
which was not
the most comfortable of scenarios
I finally took a much needed
time out
for me
even a week later
surprisingly my energy level
isn't as it should be
but I suppose laying around
can do that to you
but what is awful is this constant nasal issue
which I hope and pray
it doesn't hinder or prevent me
from working in a few short hours
that's what getting sick gets you
but to some relief
is was long over due

Reel Big Fish concert
(2/17/13)

Not the most comfortable
of places
as I am not used to
standing for long periods of time
but what a nice change
to go to a new venue
with Amanda and her friends
a celebratory moment
of my last taste of being in my 20's
new experiences of seeing people body surfing
throughout the crowd
or seeing from up above
a mosh pit of people
how interesting a scene
to observe
people being chaotic but still respectful
so much so that a young kid
stopped moshing
just to make certain a fellow mosh pitter
found his glasses
which had fallen to the ground
and a moment later
started moshing again
what a fun and exuberant
stage show to view and witness
Reel Big Fish
on February 9th
who rocked out
like none have I ever
seen live
and how grateful I am
each and every time
performers give more than 100 percent
where they played several more songs later
when the show had officially ended
but after much chanting, play one more song
the band came back out and gave the biggest finale
of songs to the audience's delight
and euphoric state

Finally Complete
march 11, 2013

Who knew a few short weeks ago
With the chaos of my mental state of mind
I would once again
Have the ability to have
the greatest joys in life
which is the love and affection
And unconditional attention
Of that of a dog
my pride and joy
such a small bundle
a teacup Chihuahua
My baby, Collette
I haven't felt this complete
In such a long time
I almost feel as though
she is Cody reincarnated
And I am so incredibly appreciative and grateful
To have the love of my life
finally reappear

To be a Ghost
(february 3, 2013)

I used to visualize
how it would be
to be a ghost
a spirit in the nether regions
of the afterlife
where an entity could
observe
and watch
the everyday woes and nuances
that people have to endure
each and every day
I used to think I could live my existence
with righting the wrongs
of my life
but after some years
growing older
possibly maturing
you realize
it is not as appealing
as you once thought
it would
or could be

My Random Thoughts
(march 20, 2013)

I'm glad of the change in Popes. After all I am a big believer in Saint Francis. The two, I pray to more frequently than most are to God and Saint Francis. They have held true for me when no one else was.

So that is why I am an advocate for Pope Francis – humility and simplicity.

Already, Pope Francis is showing to the world, how to live the better path. With a down-to-Earth approach and with a sense of humor, he's transforming Christianity and going back down to its roots.

The main foundation is of The 10 Commandments:
(taken from: http://www.allabouttruth.org/10-commandments.htm)

ONE: *'You shall have no other gods before Me.'*

TWO: *'You shall not make for yourself a carved image--any likeness of anything that is in heaven above, or that is in the earth beneath, or that is in the water under the earth.'*

THREE: *'You shall not take the name of the LORD your God in vain.'*

FOUR: *'Remember the Sabbath day, to keep it holy.'*

FIVE: *'Honor your father and your mother.'*

SIX: *'You shall not murder.'*

SEVEN: *'You shall not commit adultery.'*

EIGHT: *'You shall not steal.'*

NINE: *'You shall not bear false witness against your neighbor.'*

TEN: *'You shall not covet your neighbor's house; you shall not covet your neighbor's wife, nor his male servant, nor his female servant, nor his ox, nor his donkey, nor anything that is your neighbor's.'*

The truth of the matter is, there are way too many crimes being committed. Our judicial system isn't really doing a whole lot to use an iron fist, to basically diminish the atrocities, that is going on in our society.

It seems **excuses** are preventing repetitive criminals from staying behind bars for the rest of their lives.

It doesn't take a genius to figure out, people are lost in their morals, ethics, and mental state of mind. We rationalize the irrational and make up lame excuses for why we do the unintelligent things we do.

Wake up to your surroundings. Be mindful and actually observe and understand what is really going on (or rather what is going wrong) in your neighborhoods and communities. Make positive changes.

You can do something about it. What I can't stand most are people who think they can't do a thing to change something that is clearly wrong.

Stand up for yourself (obviously in a respectful manner) but don't let people walk over you.

You may not be in the best of surroundings but you still have rights as a human being.

Respect all living things – animals included!

My Invention Ideas:

Customer service gadget:
Basically, a small device that would light up. (either solid in color or blinking: red for <u>not needing service</u>, yellow for <u>needing the check</u> and green for <u>yes, you need service.</u>

It would be small enough that a person could purchase this item in the convenience store. That way the businesses do not have to purchase this, since most likely won't. It's an additional expense to them, that they feel wouldn't be worth it.

In my opinion, it is worth it.

I find customer service is lacking. How is a service-oriented industry, so totally inept in the one area businesses should be well-equipped. Rational Sense is non-existent.

Boat Propeller Protector:
A mechanism which would be around the propeller of a boat so that marine life and even a person who goes overboard, won't get maimed, injured, hurt, or killed by this deadly equipment.
In my mind, it's reminiscent of a fan, it still has the protective area around it, if you put a piece of paper in front of it, it still moves the paper. I'm sure there is a way this can be done on a boat where the boater still gets the speed they desire but are safeguarding the marine life.

Detector of Trains and Subway trains:

It would be similar to that of a sensor where even prior to the train passing the tracks where say a person or a vehicle is stuck on the tracks, it would automatically force the train to slow down and stop, even without the conductor's knowledge.

Too many incidents of this happening and especially people purposely throwing someone in harm's way, is very disarming and disconcerting.

A Urinator for women:

It's basically biodegradable, would be similar to, Dispoz-a-scoop. Obviously, for in an emergency case scenario and non-availability of a ladies room. Easy to use and dispose.

Rotational Bill of Hat:
The bill of the hat would be able to rotate so that if you are at a ball game outdoors, as the sun moves as day becomes dusk, the person is able to shield their eyes.

Shoe Coat:
A cover which would be in black, which would cover the bottom portion of the shoes or heels. The purpose would be to not get your shoes wet, dirty, or muddy. Some people spend an exorbitant amount of money on shoes, who wants to get it ruined, by the change of a torrential rain fall, by some gum on the sidewalk or even worse doo-doo from an animal (ducks, geese, dogs, etc...)

Adult Diaper Make-Over:
The adult diapers out there in the market are hideous and obscene. Like a baby's diaper, it should be able to be removed on the sides, not by pulling it on or off. Elderly people do not have good balance for the most part and what caretaker wants to be responsible if that person falls. But unlike a baby's diaper, it should not make that Velcro sound. Perhaps tied or has an elastic band on the sides. (A little bit more snug, form fitting and not so bulky and oversized.)

Always do the right thing. Don't settle for less and always stand up for yourself, in a respectful and productive manner. Make the most of it.

www.ingramcontent.com/pod-product-compliance
Lightning Source LLC
Chambersburg PA
CBHW041616180526
45159CB00002BC/876